For
John & Christy
Enjoy
Love Pat.

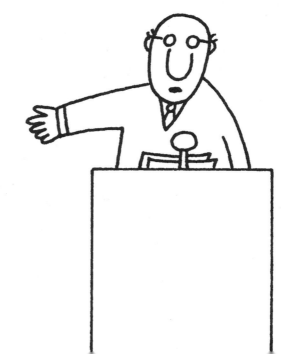

They Moved My Bowl

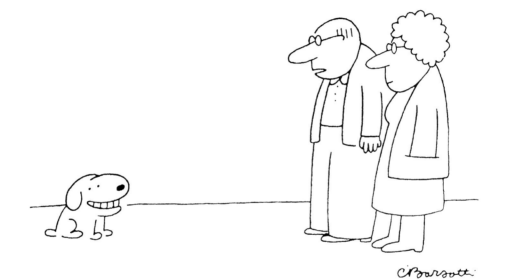

"You're right, he is smiling. Now get him to stop."

They Moved My Bowl

Dog Cartoons by *New Yorker* Cartoonist
Charles Barsotti

Foreword by George Booth

LITTLE, BROWN AND COMPANY
NEW YORK • BOSTON • LONDON

In memory of Jiggs,
the world's greatest dog

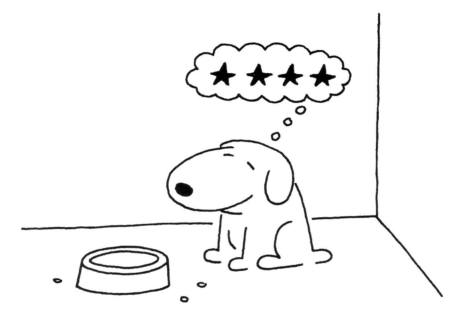

FOREWORD

Charley Barsotti is a longtime friend. When he asked me to write a few words for this book I said, "I'm going to write a bunch of lies about you!" I didn't.

Barsotti is a whole package. First, an idea man. Then, the refined idea. And the right drawing. He zeroes in on the target. Art! You know that. Or you are invited to discover it soon in *They Moved My Bowl.*

Here is a Barsotti: One mild-mannered pup says to another, "My bark is worse than my bite, and my bark is sort of a yap." Think of all the barks out there that are really only yaps.

Another Barsotti: Executive dog behind desk to possible employee dog: "And when the time comes, the company will put you to sleep at its own expense."

Caution: When you are alone on the park bench across from the post office and you recall a Barsotti, *do not* giggle in a strange manner; when eating spaghetti, be careful; when on a train in a seat for three being squeezed from both sides, and you think about a Barsotti, *do not* giggle; and during intimate moments with your yokemate, *do not* giggle or snort at a Barsotti. Especially *do not* snort!

George Booth

PUSSYCAT

..and nicely rendered, too.

One G. Booth

May 23, 1990

Mr. Charles Barsotti
419 E. 55th Street
Kansas City, MO 64110

Dear Charles:

I have been wanting to write to you for
some time to tell you of my admiration
for the work you have been doing.

I think the little dogs that you draw
are the funniest cartoons that anyone
has been doing in recent years. I
keep hoping that someone will collect
them all in book form some day.

Best regards with great admiration,

Charles M. Schulz

CMS/pl

They Moved My Bowl

"O.K., laugh, but this is going to be my ticket out of here."

"It's O.K. I'm not really in the mood, either."

"I'm back. Move."

"The special, sir. Shall I spread it out or will you knock it over yourself?"

"If elected I promise to fetch, beg and roll over."

"I do what they tell me, I eat what they give me.
How do I know they're not a cult?"

"Well, it's not my fault. You can see that it says
'Gourmet' right on the can."

"Front yard. All's quiet. Over and out."

HANGING OUT

"I'm not angry, I'm just <u>very</u> disappointed."

"It's been moved that we adjourn for an afternoon nap.
Is there a second?"

"And what do you think will happen if you <u>do</u> get on the couch?"

"*The bidding will start at eleven million dollars.*"

"Talk? Hell, after a few drinks you can't shut me up."

"I had to bite him once, but now I always get a great table."

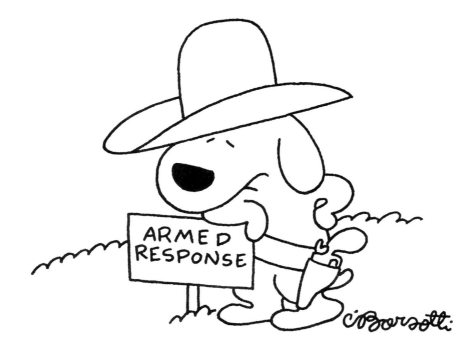

"Stay cool — we're picking up a lot of chatter."

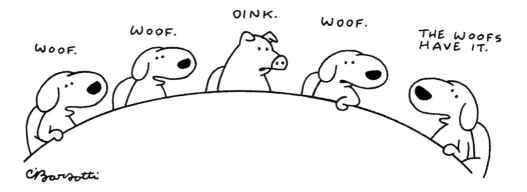

COMING SOON

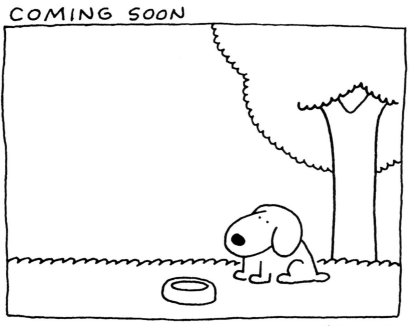

"The rug will not be sent out for lab tests."

"I give you the seven-billion-dollar pup,
then you give me back the seven-billion-dollar pup,
and we've each made seven billion dollars."

"Oh, God, am I housebroken."

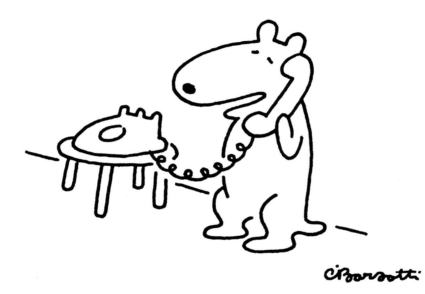

*"Well, please look again, Operator. It's Fluffy —
F-L-U-F-F-Y — and she lives in Larchmont."*

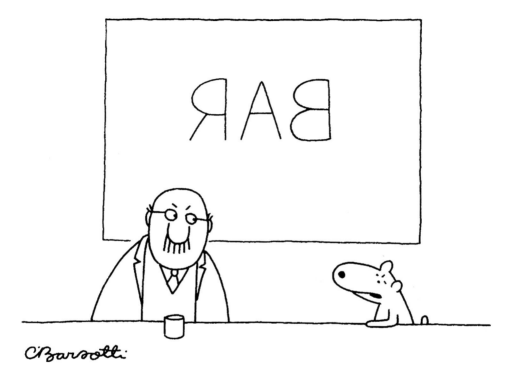

"Yeah? Well, I happen to know that <u>you're</u>
not supposed to be in here, either."

"*My bark is worse than my bite, and my bark is sort of a yap.*"

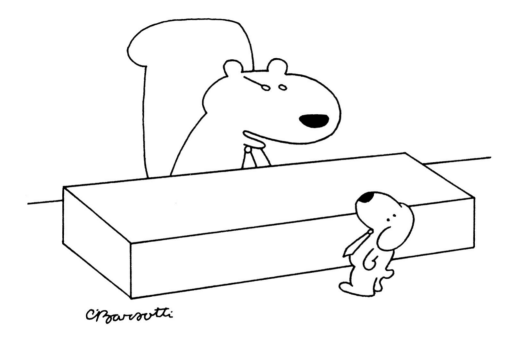

"*The old tricks, young fellow, have served me well.*"

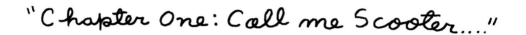

"Chapter One: Call me Scooter...."

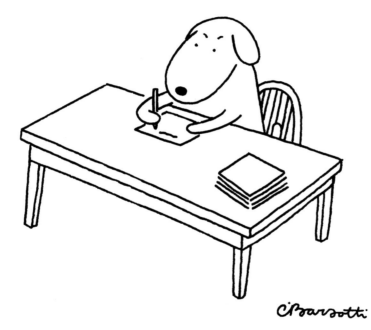

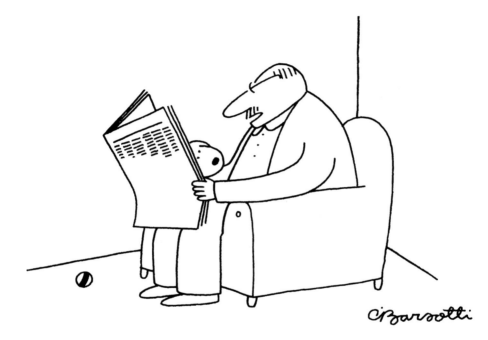

"*What the hell did you do with your day before I retired?*"

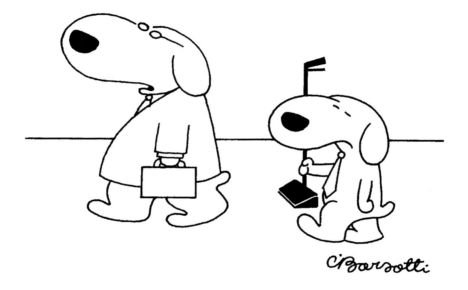

"Now, now, Harrison, we all start somewhere."

"Of <u>course</u> the company appreciates your years of loyalty."

"I bark at everything. Can't go wrong that way."

"First, can we agree that it's a big back yard?"

"Yes, they _are_ crazy, but they can open the fridge."

"File!"

"Keep talking, I'm listening."

"*It's non-negotiable.*"

"*Scooting across the lobby rug on your butt, that's <u>not</u> the behavior I expect from a vice-president of this corporation.*"

"They <u>think</u> they're accidents."

"Today's lecture is on loyalty."

"*Not guilty. He needed new Top-Siders anyway.*"

"*Must you people always call at dinnertime?*"

"I'll have what he's having."

"*Whenever you're ready.*"

"*They throw it, I chase it — there are worse gigs.*"

" 'Bad dog, bad dog,' she said. 'We should have gotten a cat.' "

"My advice is to learn all the tricks you can while you're young."

"But first, a distraction."

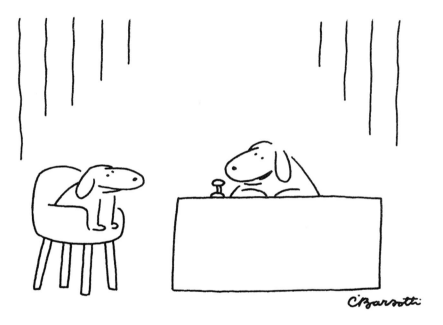

"I understand you've learned some new tricks
since you were here last."

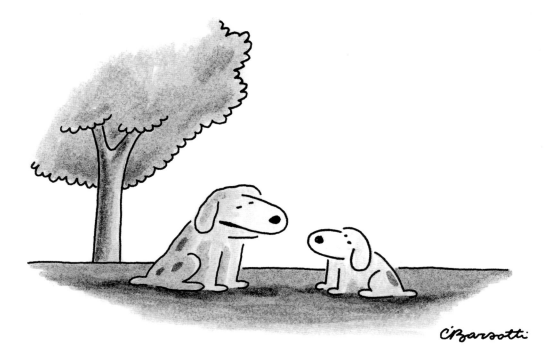

"Pay attention to what I say, kid,
I've been around the block."

"So you're little Bobbie; well, Rex here has been going on and on about you for the last 50 years."

"Dog bites man, eh? Great, we'll hold the front page."

"*I never used to think in terms of dog years.*"

HAPPY HOUR

DIAL-A-PAL

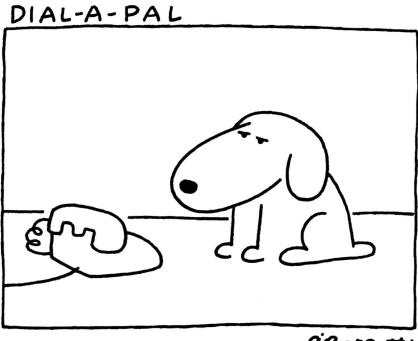

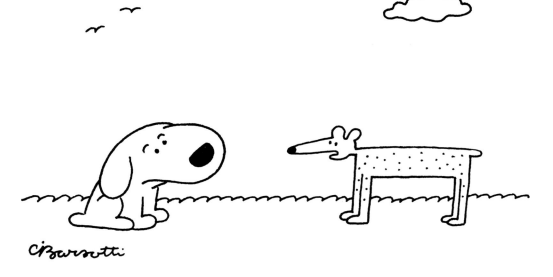

"*I was clipped for summer.*"

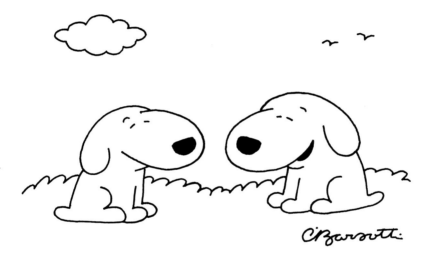

"Hey, do you want to hear a good cat joke?"

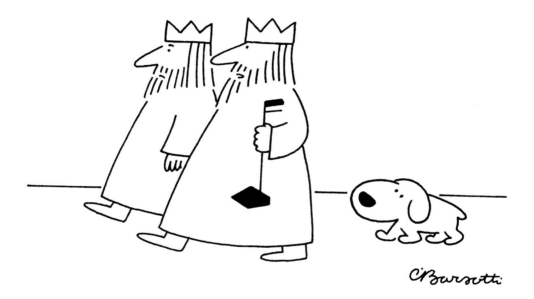

"It's good for my image."

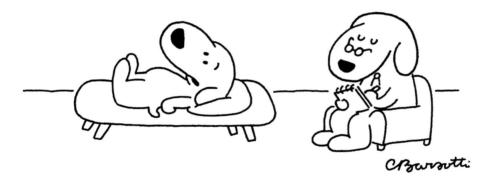

"If I didn't know before I sure as hell know who Manolo Blahnik is now."

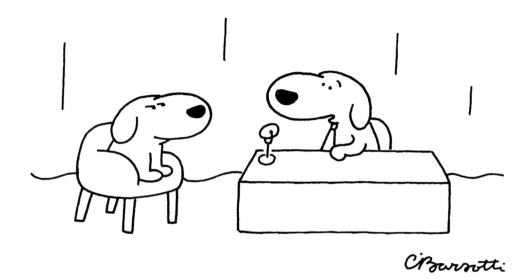

"*So you woke up and found yourself in the pound.*
Is that when you decided to turn your life around?"

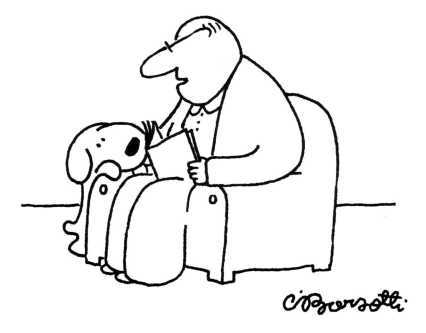

"Yeah, I'm O.K. Are you O.K.?"

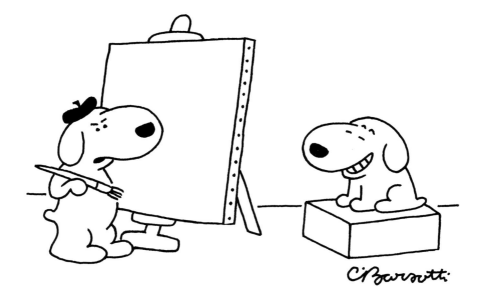

"Cut that out."

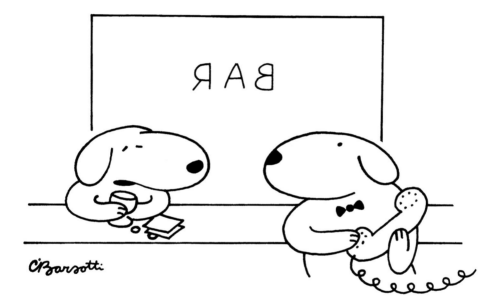

"Tell him to fetch his own damn slippers."

"You heard me, pal, the bitch gets the part."

"As unbelievable as it may seem to you today,
this court was once a puppy, too."

"It's agreed then, we'll name him Rex and keep him."

"*Don't be so smug, all puppies are cute.*"

"The damn cat's got caller ID."

"I'm a bad dog. I'm a bad dog. I'm a _really_ bad dog."

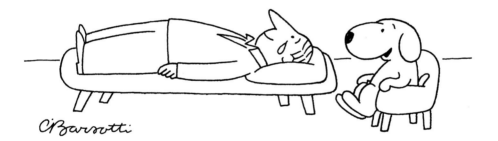

"Well, _I_ think you're wonderful."

"I'm trying to deal directly with my fears."

A WELL-TRAINED PET IS A JOY FOR ALL

C Barsotti

"Someday, my son, that will mean you."

"When I'm ready to retire I'll call <u>you</u> about a goddam burglar alarm."

"I'm trained, yes, but not highly trained."

"All the interesting traits have been bred out of me."

"They're out. It's the damn answering machine."

"*Yes, I'm talking to you. I believe you're the only Sparky in the house.*"

"Unconditional love? I don't think so."

"My God, will I ever stop falling for that fake throw?"

"*Oh, I <u>would</u> bite, but only if the cause were just.*"

"Not guilty, because puppies do these things."

"Thanks for asking, but no. My frisbee days are behind me."